A POCKET FULL OF HEAVEN

Pamela Schuyler

ISBN 978-1-957220-24-6 (paperback)
ISBN 978-1-957220-25-3 (digital)

A POCKET FULL OF HEAVEN

Pamela Schuyler

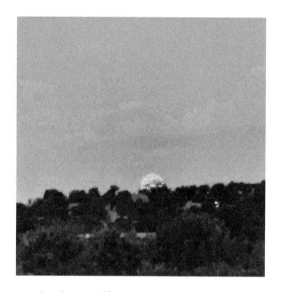

Is there really a man in the moon?

Mostly Skies From Santa Fe, New Mexico

I moved to Santa Fe, New Mexico a little more than a year ago. The skies lured me here with their vast changing beauty. I found a wonderful home in Zocalo, Santa Fe that wakes me up to magnificent sunrises and lulls me into meditation and sleep with the ever-changing sunsets and moon rises.

I often wonder whether it can be the same sky. In a magic moment I can see the mood of the sky change from light to dark, from fire to rain, from calm to chaos. Always peace at the end of the day when the sky darkens and the sun's light disappears and the clouds merge into night.

My life absorbs the pallet of the sky's colors from sunrise to sunset, from moonrise to moonset.

As an artist I create the creations which already exist in the universe, that inspire me. My heart expresses my feelings and intuition. My mind interprets and reflects these feelings. My spirit ignites my creativity and I draw, paint, sculpt, photograph and write.

Now I share with you glimpses of my inspiration through my photography. My camera equipment changed from heavy photographic equipment, to lightening my load with my iPhone. These images have evolved with this new tool. And so my friends these photographs were made mostly from my home in Santa Fe and the surrounding areas of the southwest. With additional travels and years there are images from Colorado, Arizona and Iceland.

JUST LOOK UP IT IS OUR BEST THERAPY!

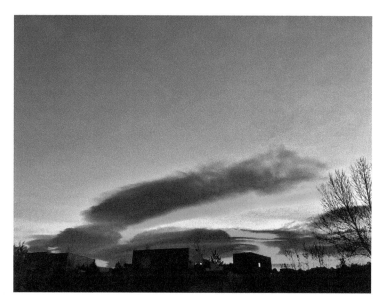

Sunrise Illuminations.

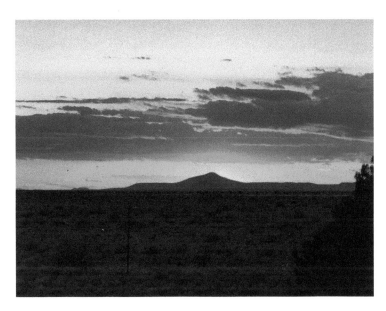

Sunset Illuminations.

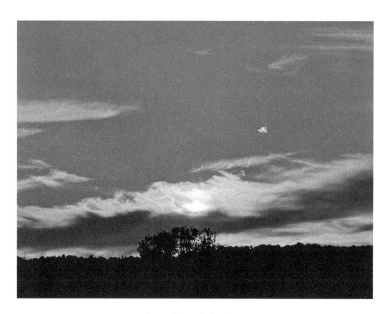

Patches of lights.

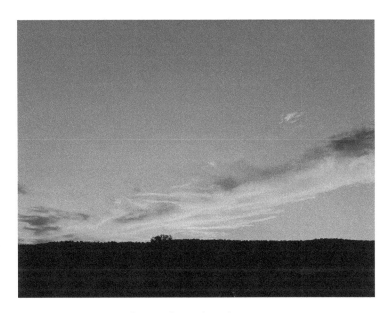

Broad band brush stroke

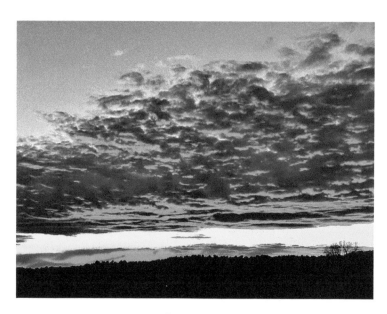

Intensity.

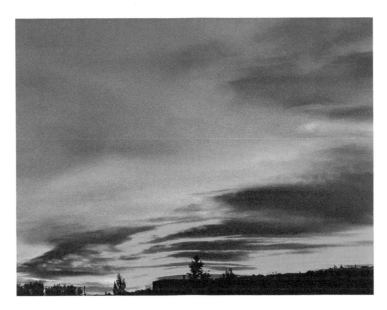

Morning Light.

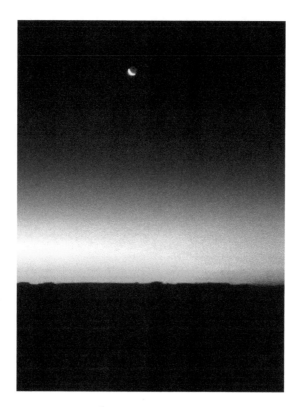

Stripes to sunrise.

Attachment.

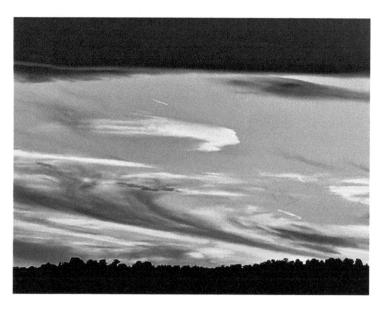

Atmospheric churning.

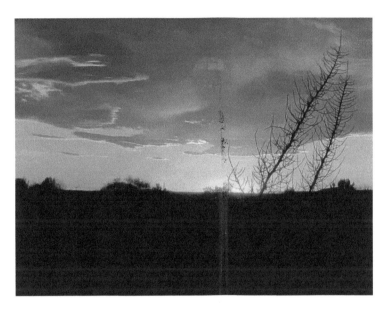

A pairing.

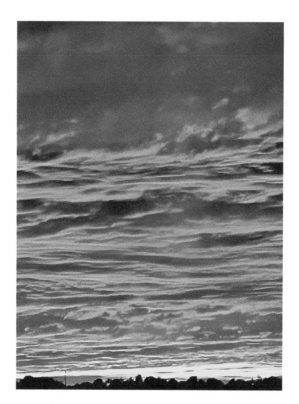

Colors so intense one's heart throbs.

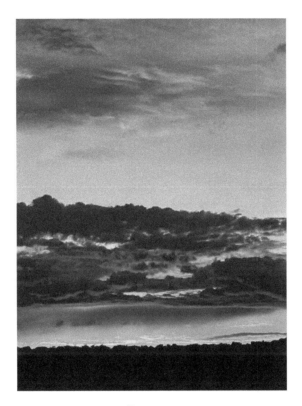

Tapestry.

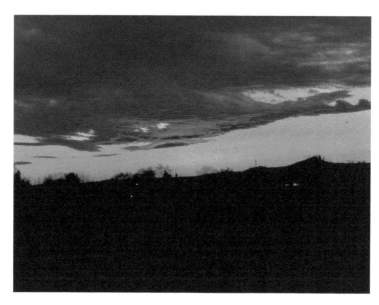

The universe's palette, so bold.

Poof!

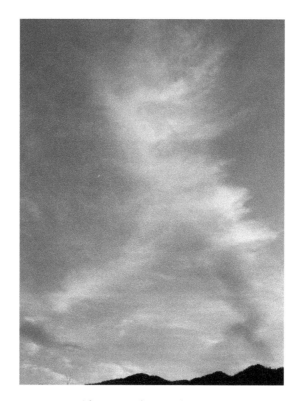

Clouds walking the earth.

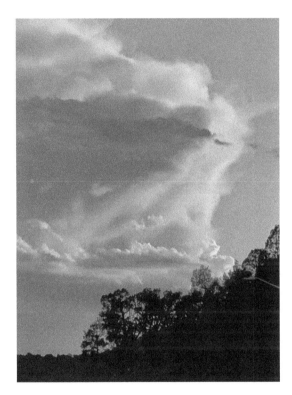

Clouds dance.

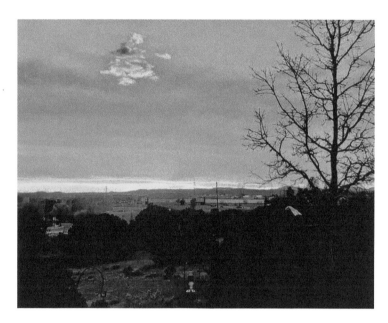

Fireworks.

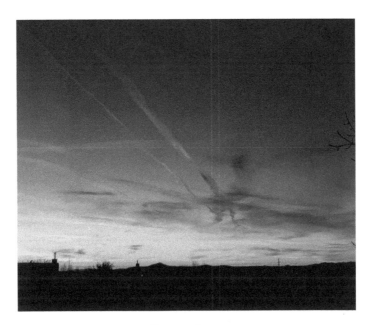

Energy burst.

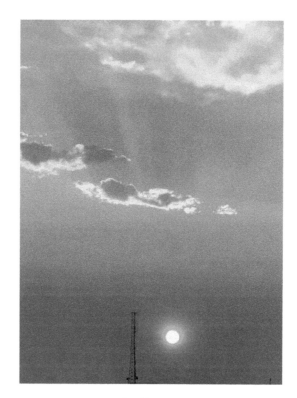

Pollution

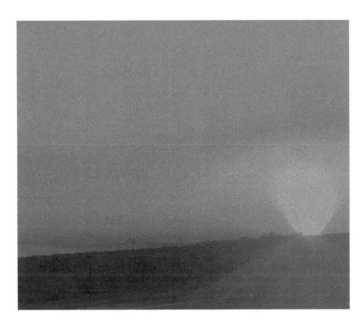

Burning bright the day.

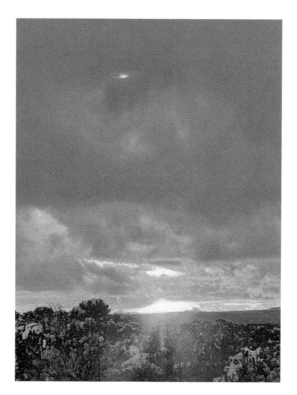

Yolks broken.

Banners of sunrise.

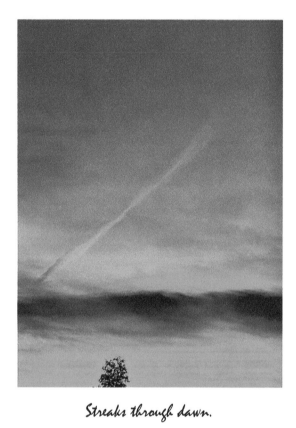

Streaks through dawn.

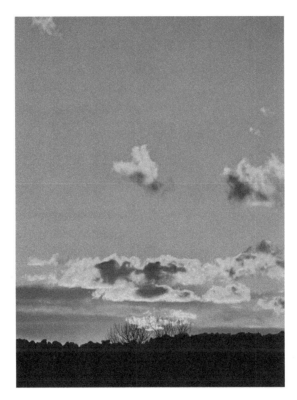

Splotches.

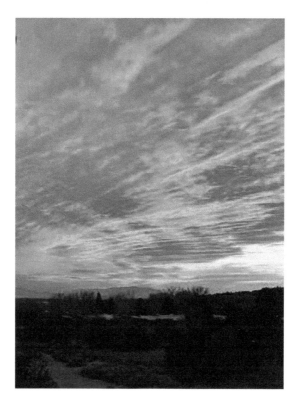

Moving diagonals to end of day.

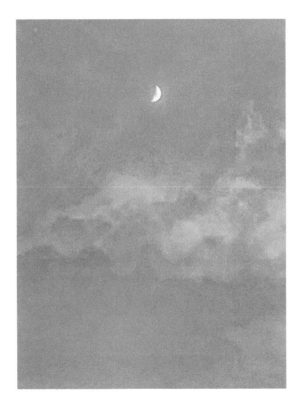

Pastels to early moon rise.

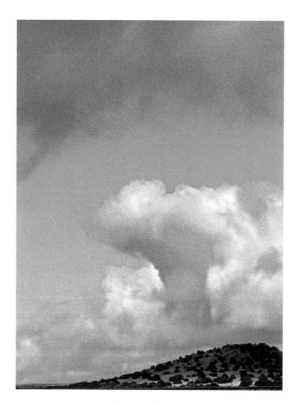

Disturbance.

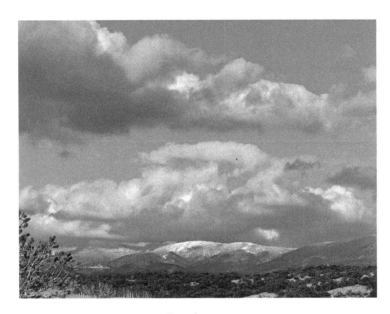

Resolution.

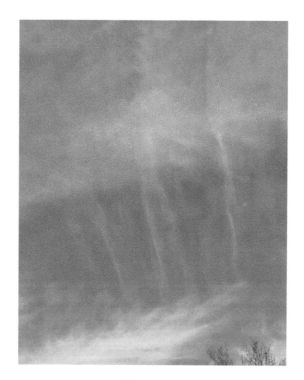

Streamers.

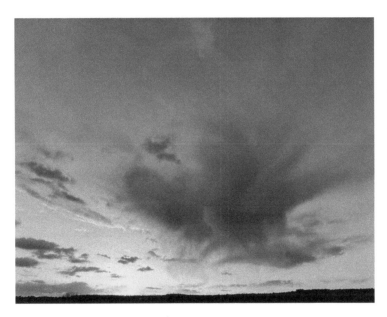

Helter skelter.

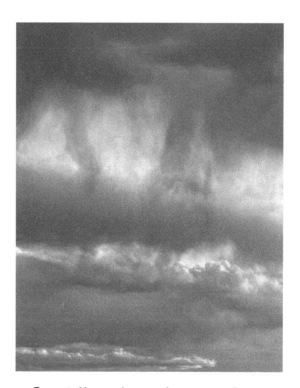

Tears falling releasing layer upon layer.

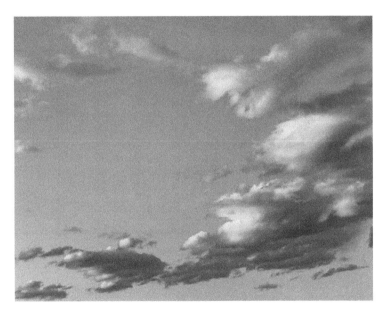

Circlet.

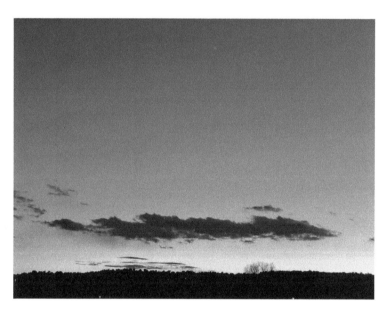

Line by line to small print.

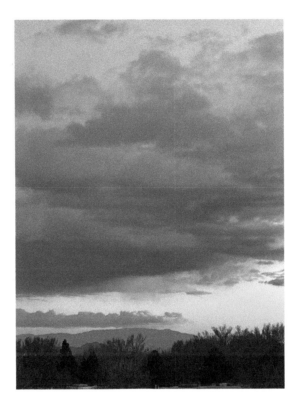

Shades of colors.

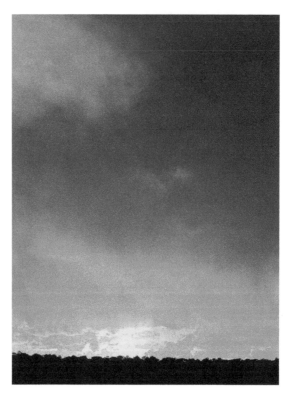

The sun's rays set the clouds on fire.

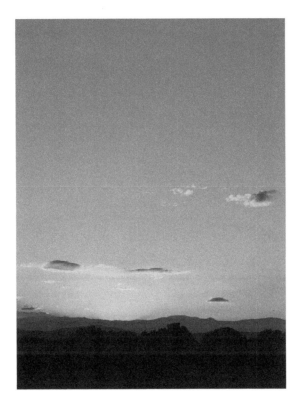

Not everything is complicated.

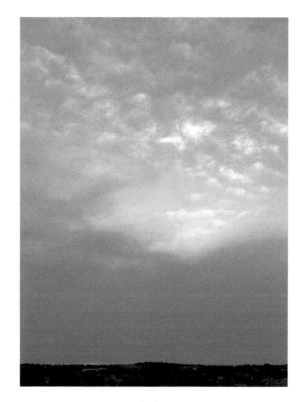

Calm.

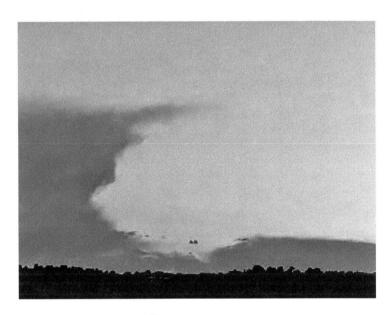

Opening curtain.

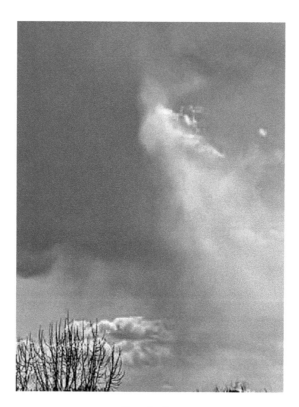

Spotlight.

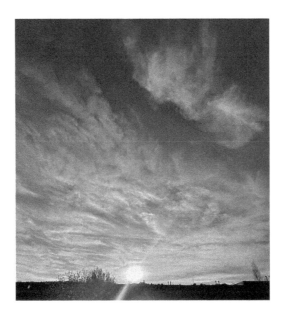

It's all in the lighting.

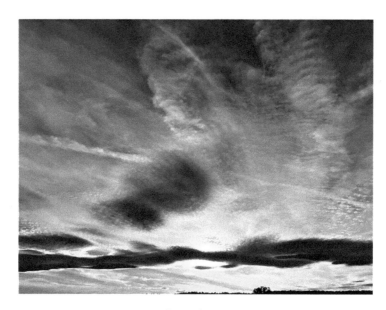

Cacophony.

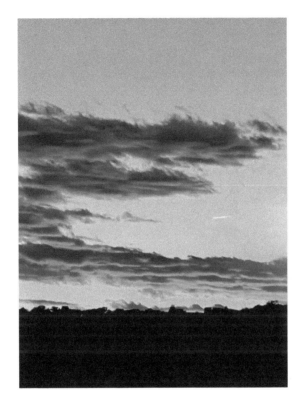

Electrifying.

Flatline.

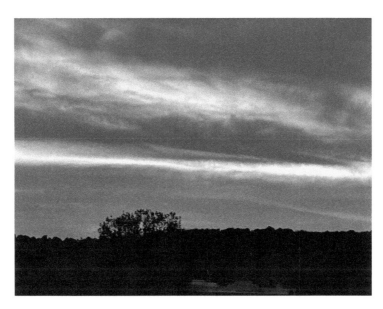

Night blends the colors of the day.

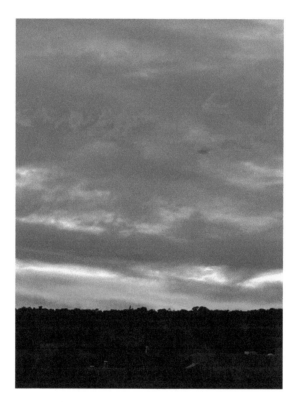

Dreams received, dreams let go.

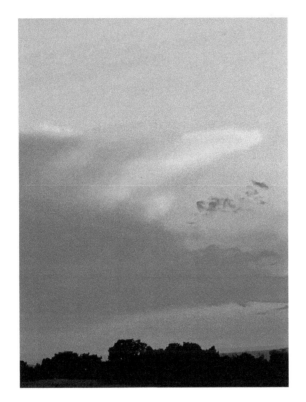

Subtle transitions.

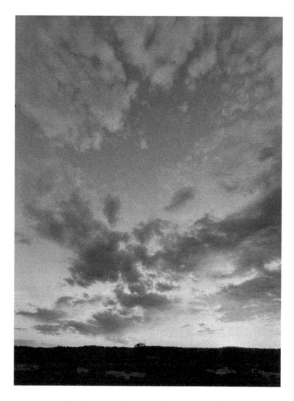

Confusion from day to night.

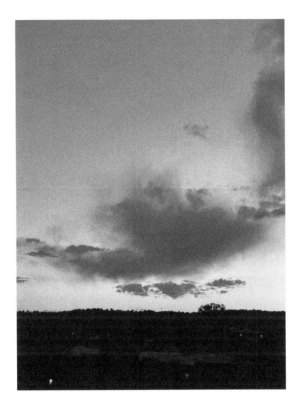

Three hovering little clouds.

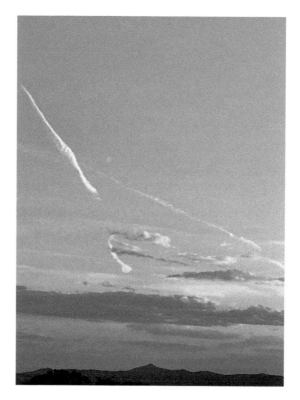

Linear collaboration.

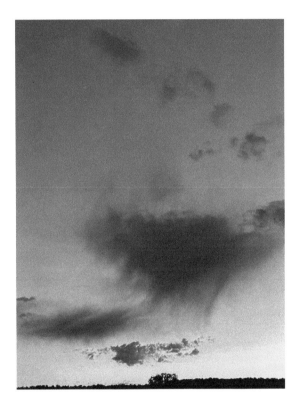

Filling the clouds below.

Mountainous clouds over mesas.

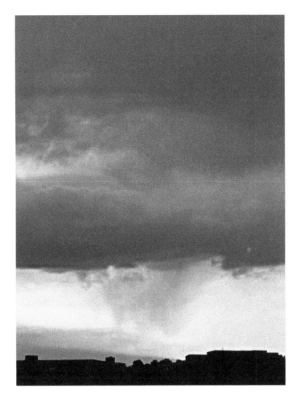

Showers.

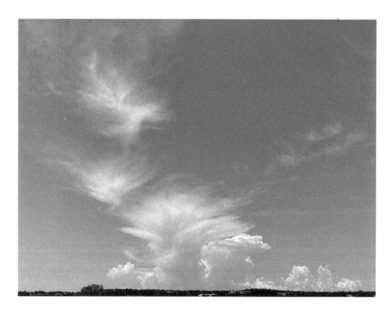

Feather duster clouds.

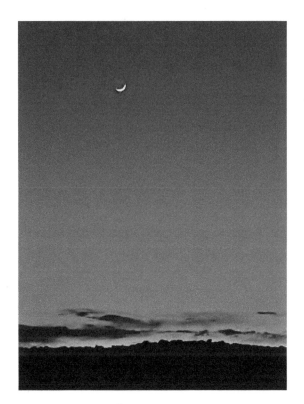

Sweet dreams.

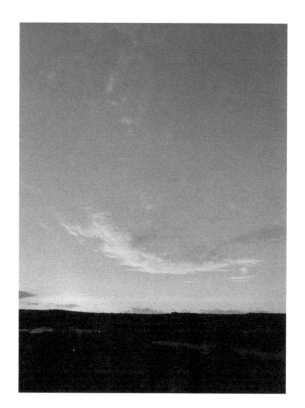

Blessings.

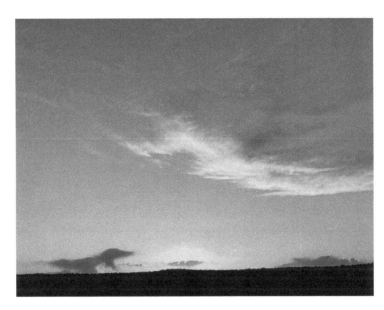

A dinosaur cloud eating little clouds at sunset.

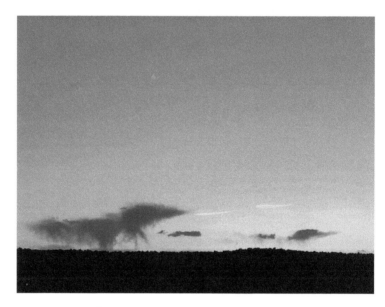

When dinosaurs walked the earth.

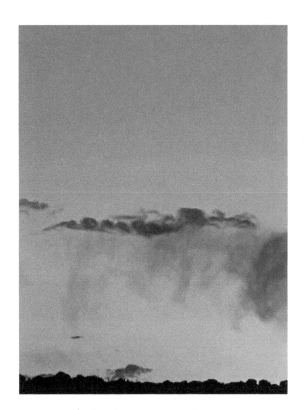

Skeletal remains of history.

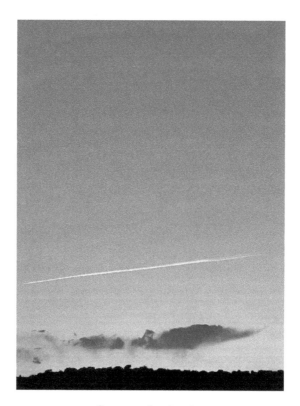

Racing the clouds.

Scratch.

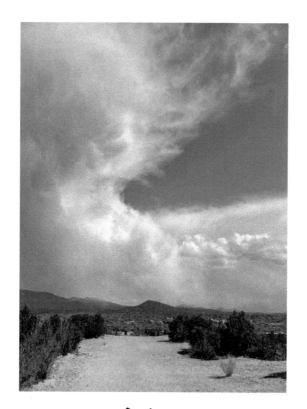

Pathway.

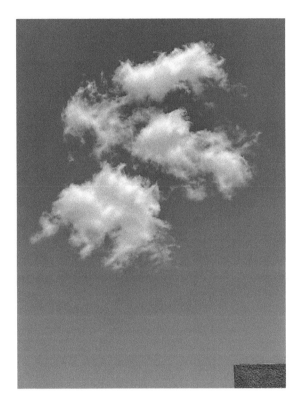

Clearly floating.

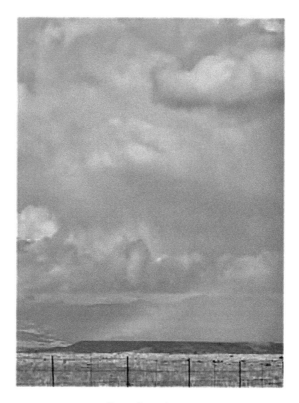

Rainbow days.

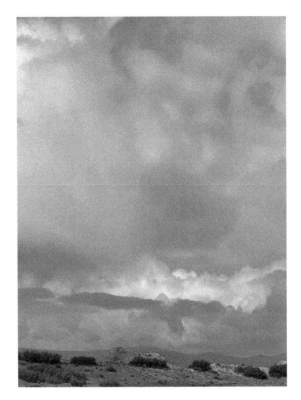

An eagle soars.

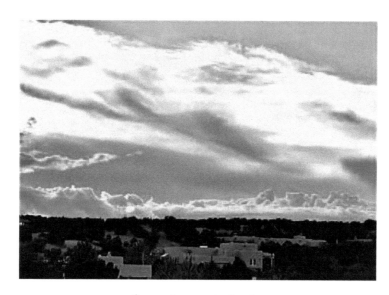

An audience of clouds.

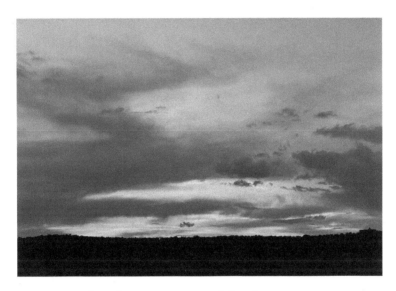

Another canvas painted by the universe.

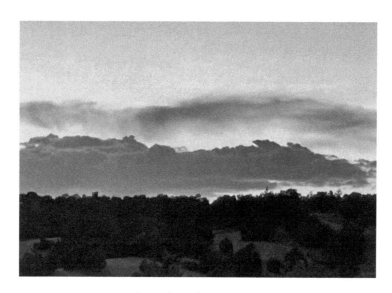

Orderly colors emerge.

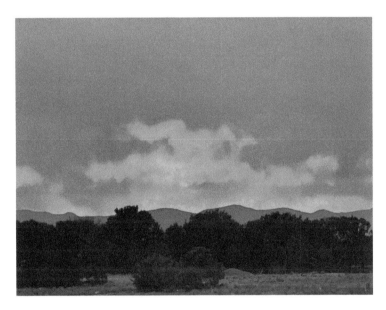

Mischievous cloud figures in the sky.

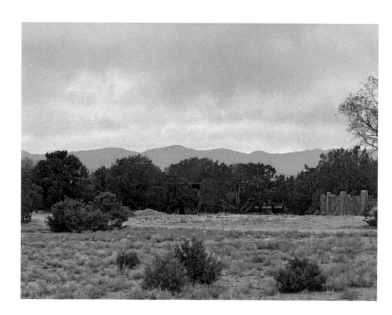

Fading.

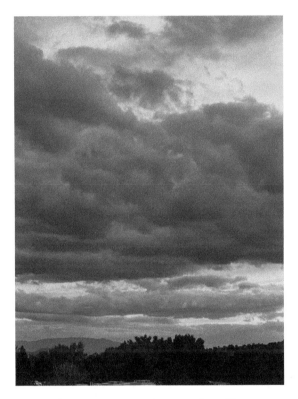

Summer smoke changes the pallet.

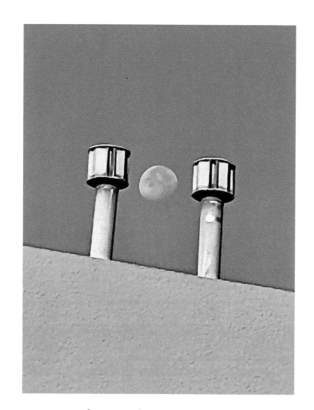

A period between thoughts.

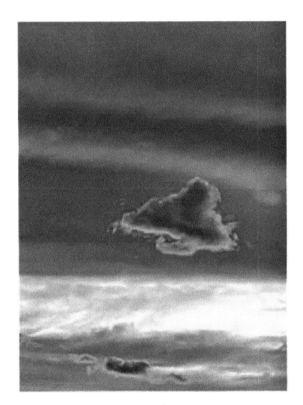

little black cloud connections.

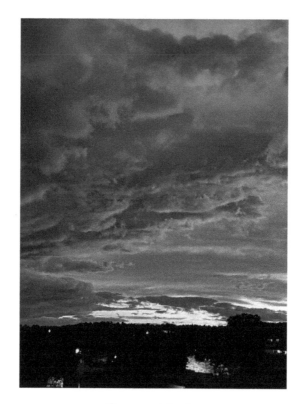

Beacon of light.

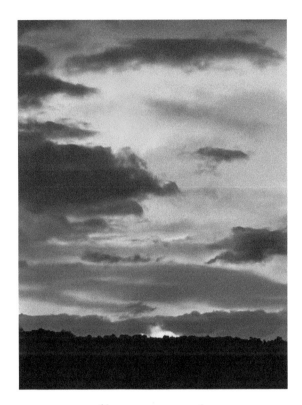

Slipping into night.

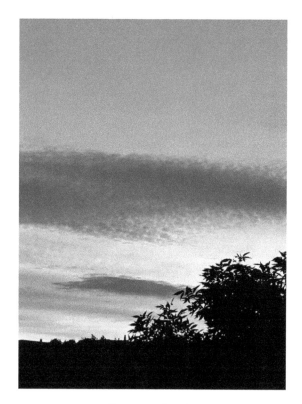

Erasing clouds.

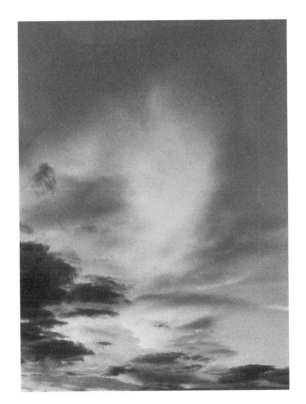

An illuminated sky geyser.

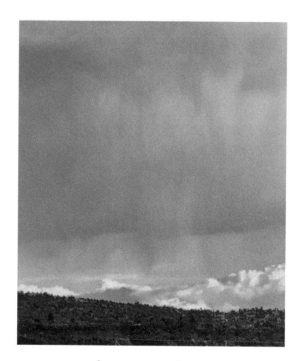

Piercing rainbows.

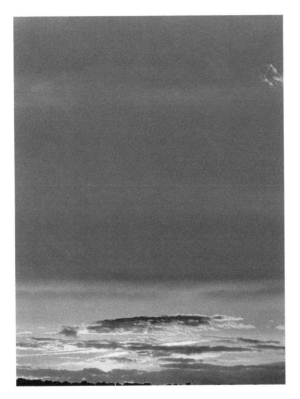

Our universe.

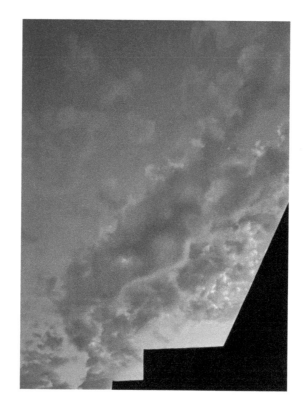

Sharing space.

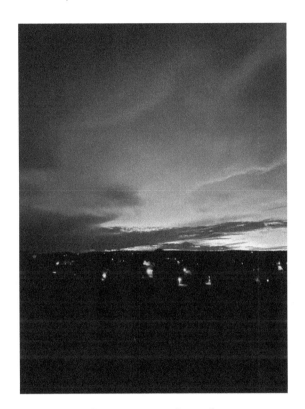

Campsites in the night.

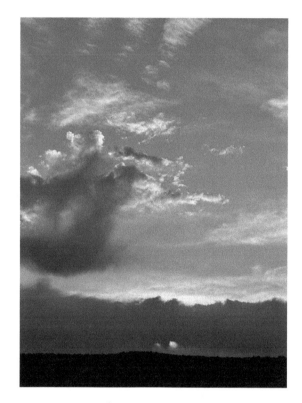

Determination.

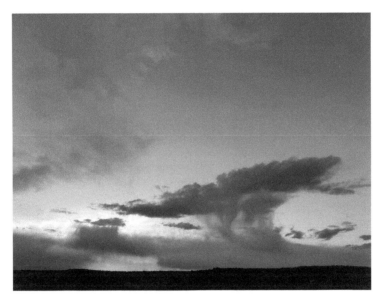

A whale of a tale jumps over the sunset.

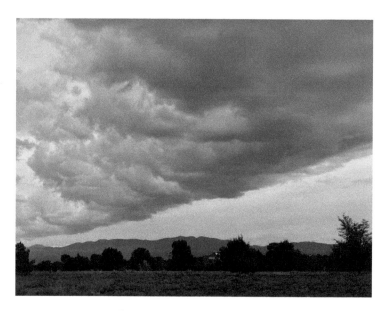

And the cloud, she blushes.

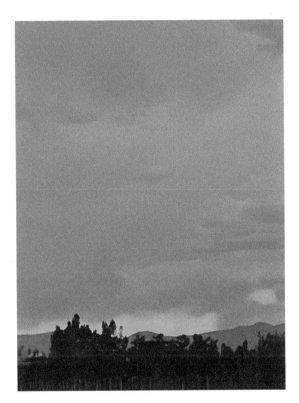

Burning embers of the day.

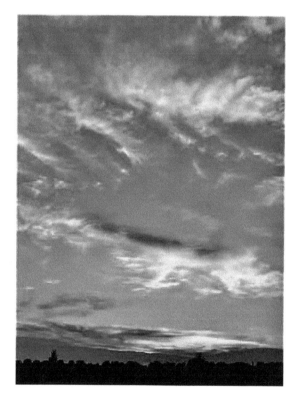

Movement.

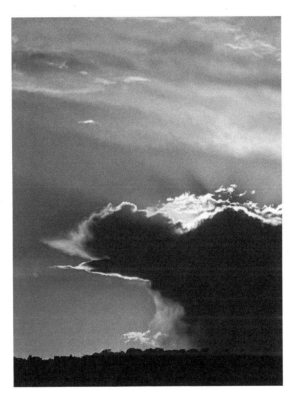

Clouds gushing upwards.

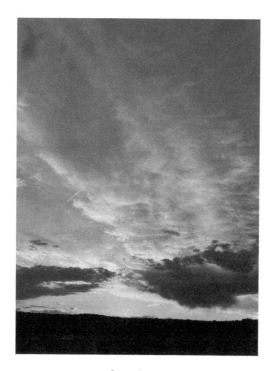

Reaching.

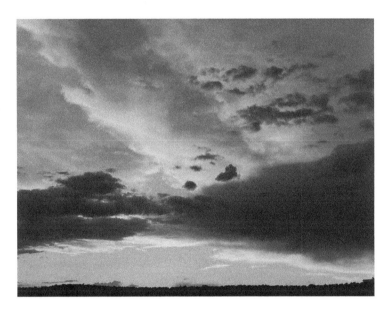

Cloud puppets.

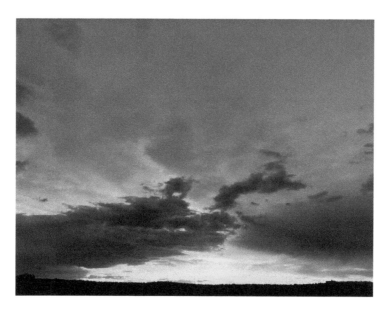

Smash!

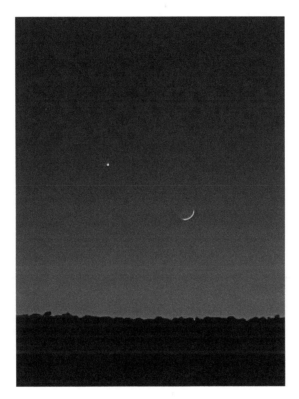

Venus smiles on the new moon.

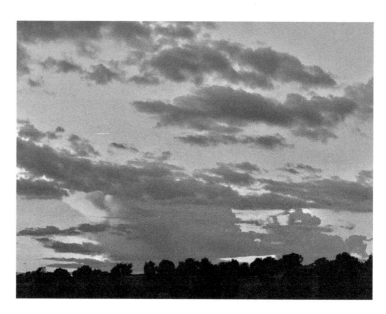

Color density.

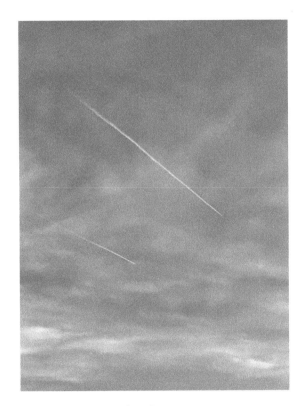

Sky Racers.

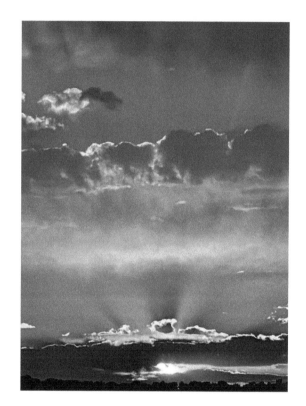

Exclamation!

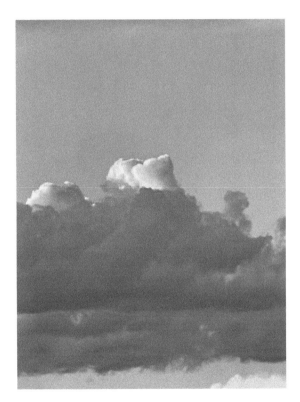

Whipped cream covering.

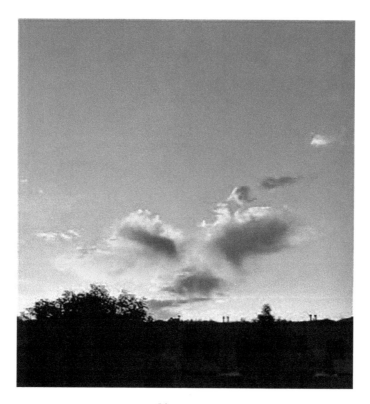

Fly away.

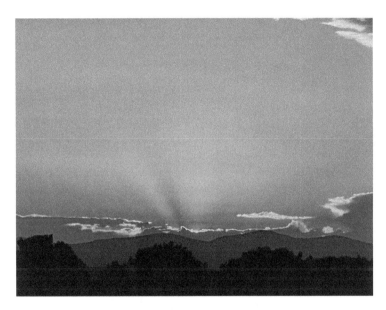

Beams through last light.

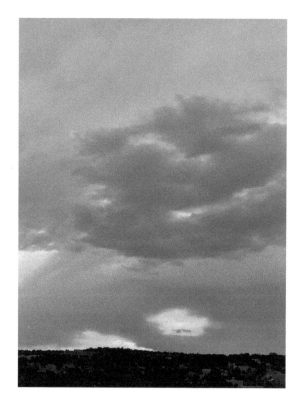

Fried eggs over well.

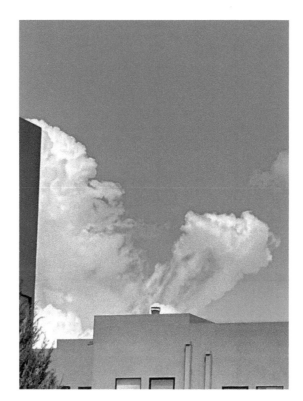

A jelly fish cloud!

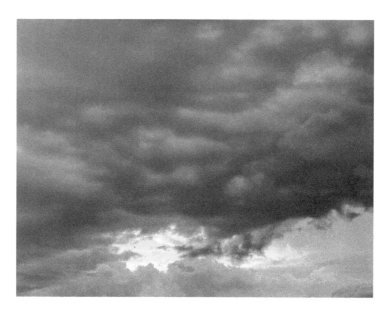

Hole.

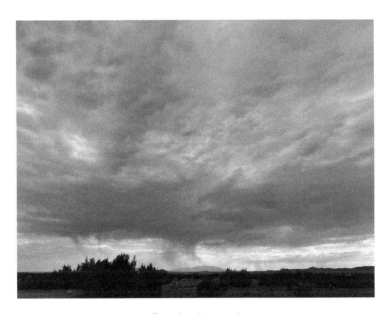

Tickle the earth.

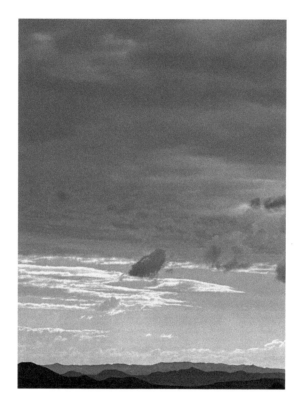

Rocket through the clouds.

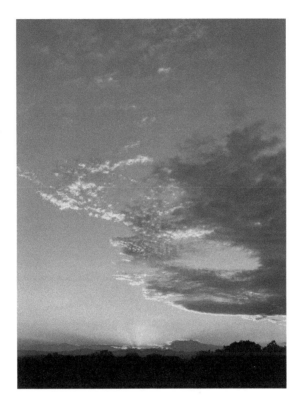

It's ok to let the day go.

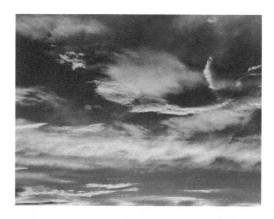

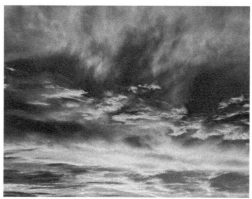

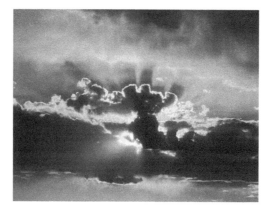

One day all in a moment.

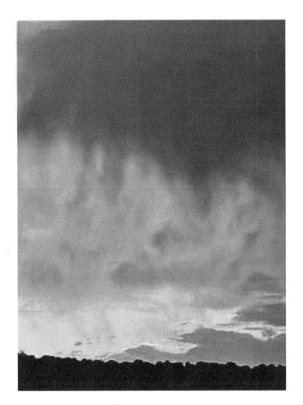

Sunsetting fire.

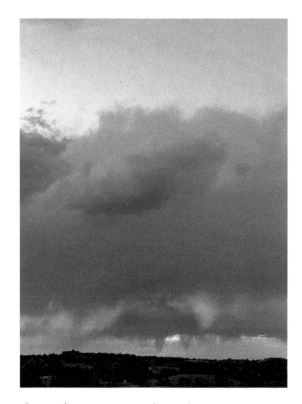

Rain clouds extinguishing the fires of sunset.

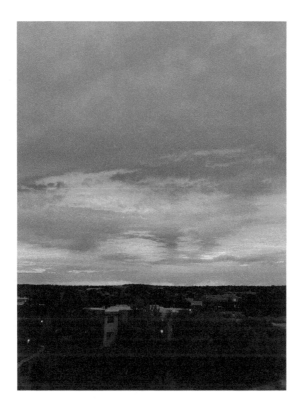

Cutting into the clouds.

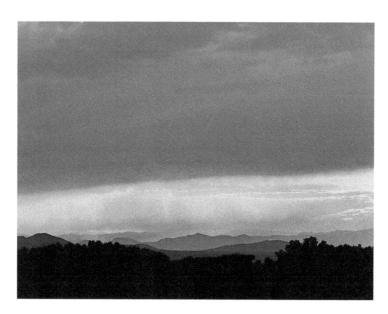

Colors pale.

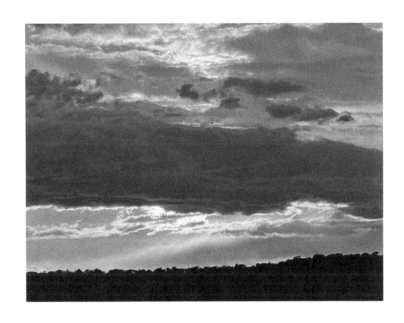

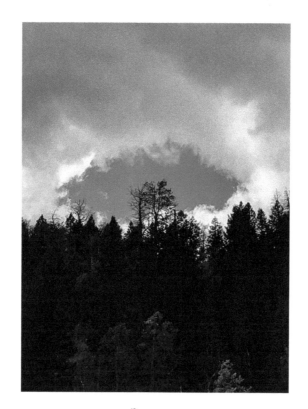

Opening.

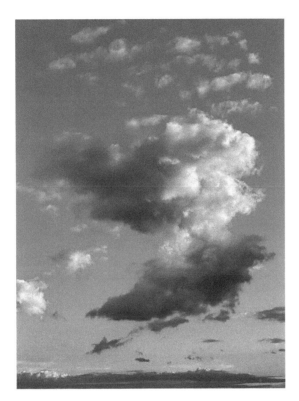

lifting away old thoughts.

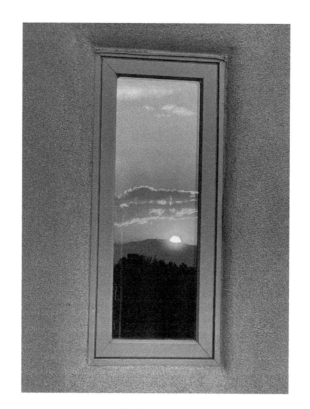

Reflections.

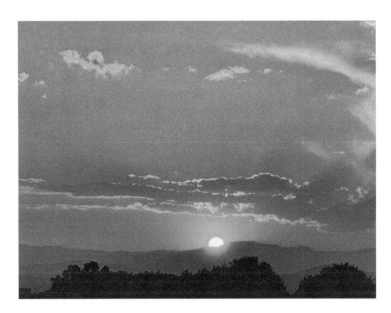

Reflecting.

Sunset in the hood.

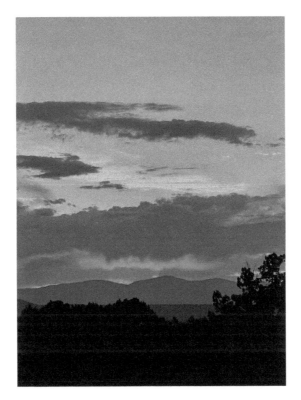

Colors shift.

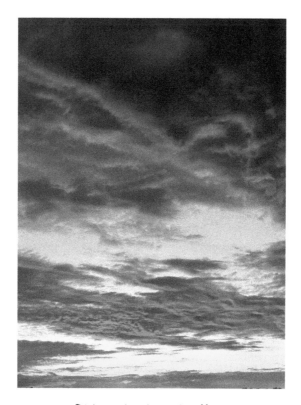

Reds and reds and yellow.

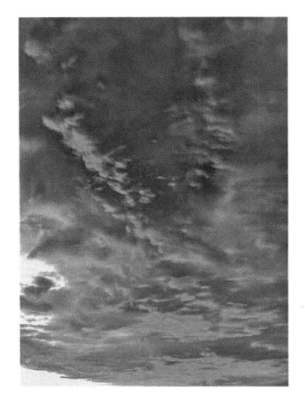

Heaviness.

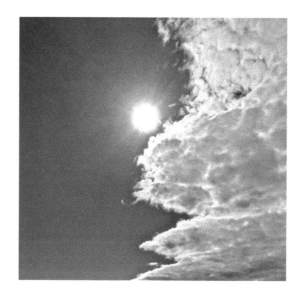

Clouds with rolling shores.

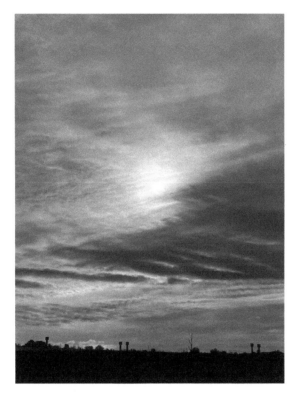

Hide and seek.

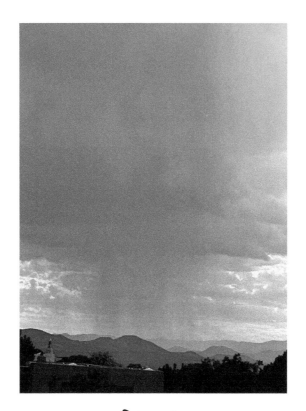

Rain, rain

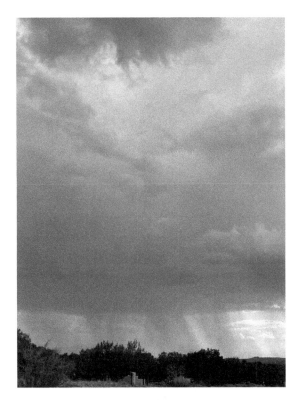

will stay another day.

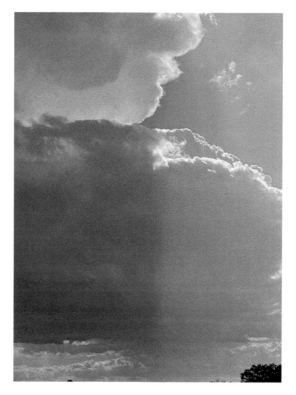

Veiled.

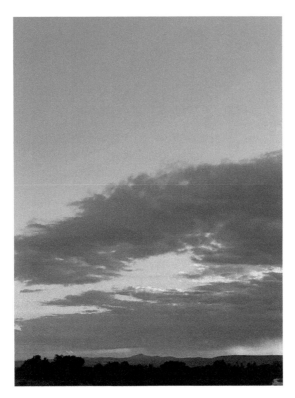

Portal.

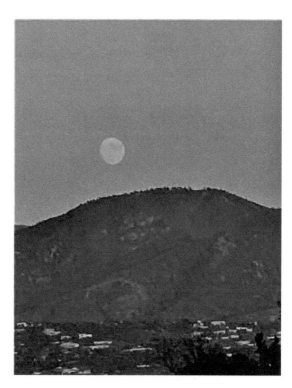

In early evening haze the moon pops up.

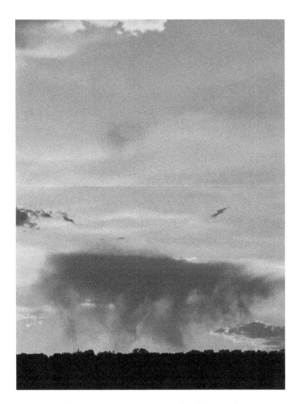

Fingers of rain touch the earth.

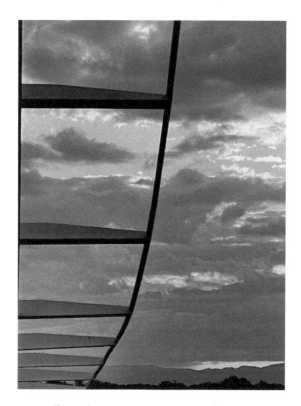

One of many stairways to heaven.

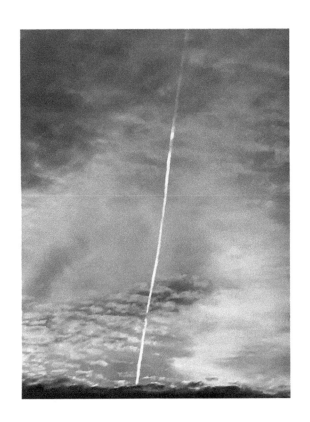

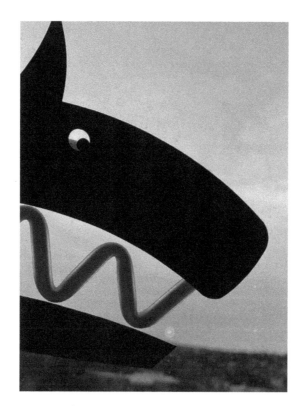

A dog barks and eats the sun.

A crow laughs and gives the sun back.

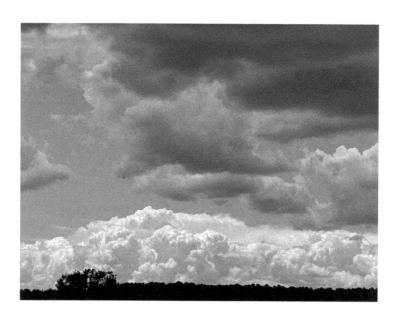

Imagery emerges.

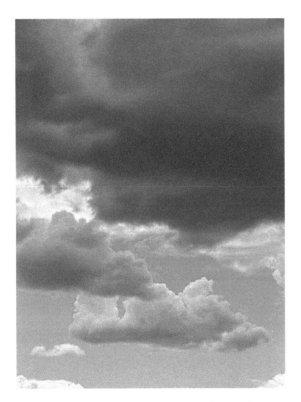

Upside down critters dancing on the clouds.

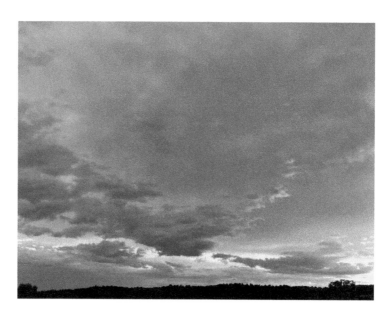

Blanketing the earth.

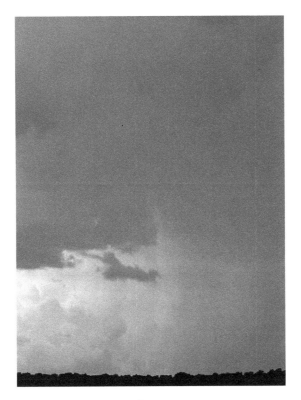

Sweep.

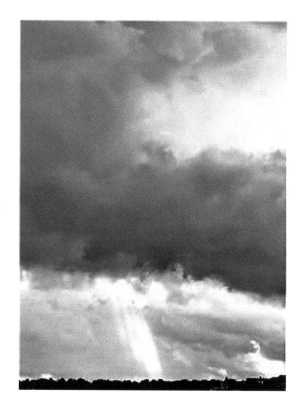

Touching earth.

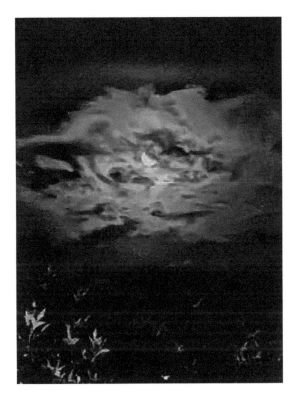

Tempest moon.

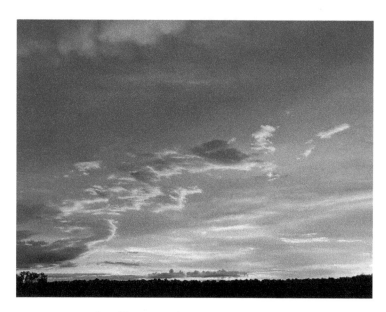

Small script clouds at the horizon.

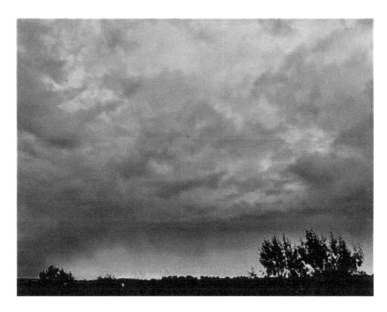

Open stage.

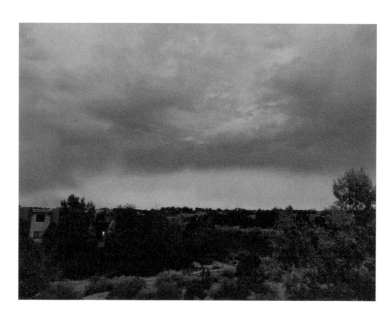

Heavenly fires.

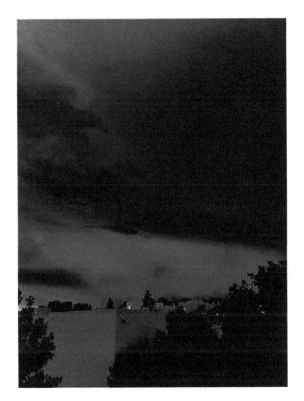

Reds fading into darkness.

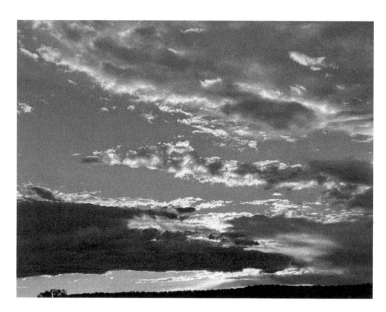

lighting the clouds.

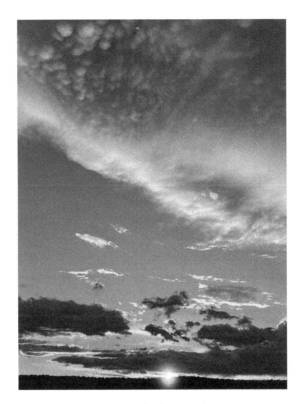

Evening's last light.

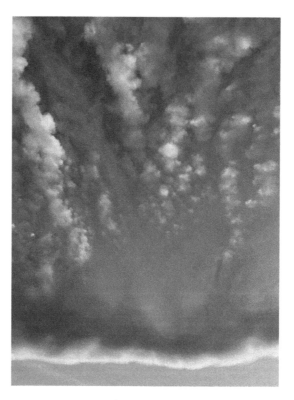

Sky bubbles.

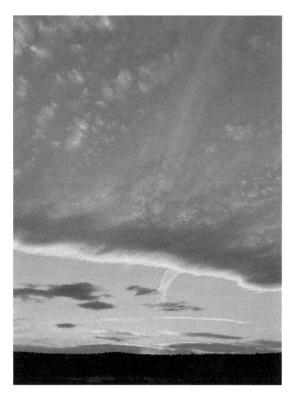

Just imagine.

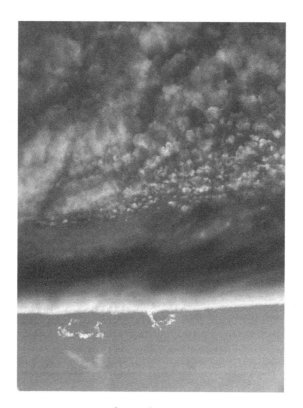

Detachment.

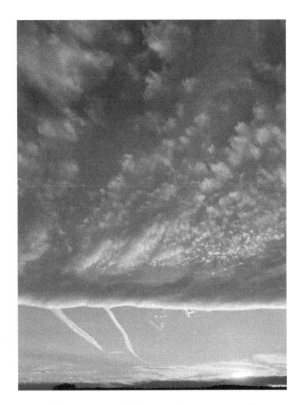

Sky writers drifting down to earth.

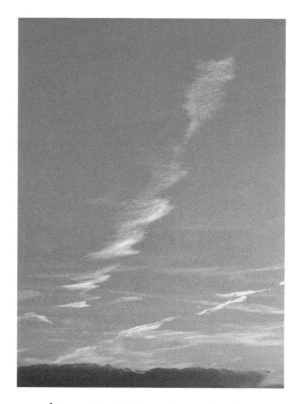

Sky writing fades into another day.

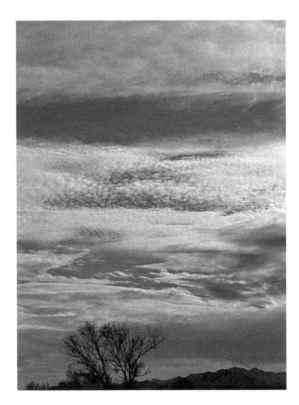

Clouds' currents. Current clouds.

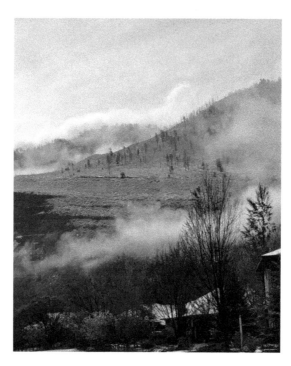

Falling clouds.

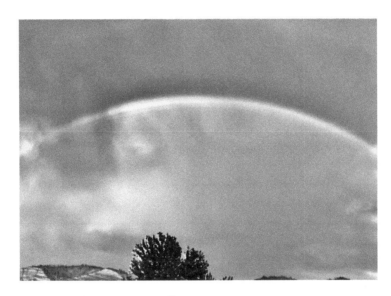

Connection.

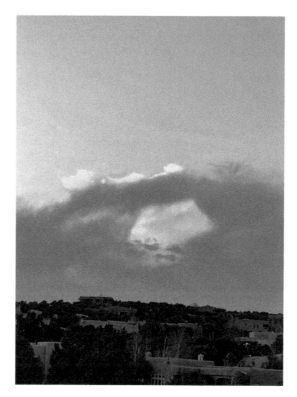

Two clouds touch.

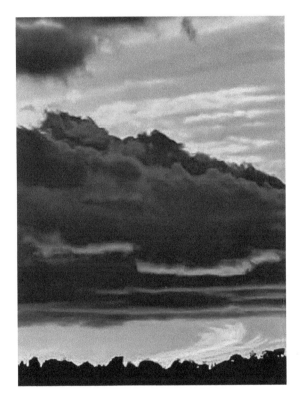

Swirls.

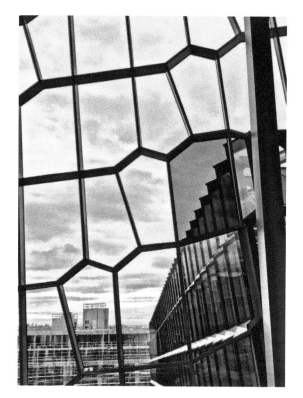

Man's kaleidoscope on heaven.

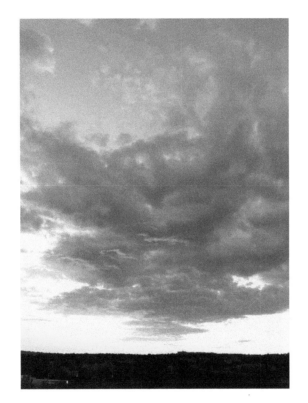

Colors above the horizon.

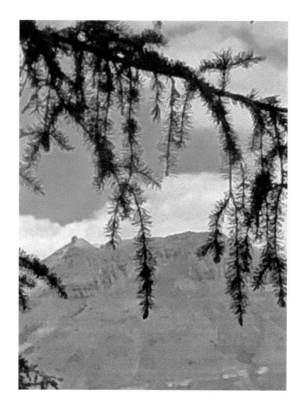

Bough to heaven.

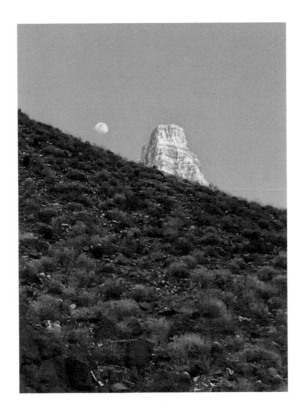

Canyon's edge.

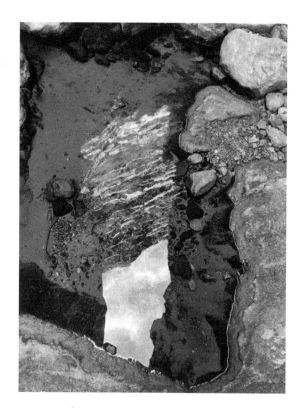

Peering through the Canyon.

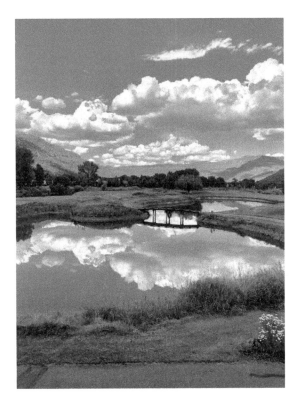

Upside down, right side up.

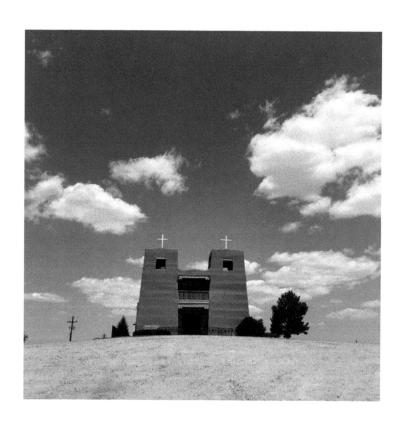

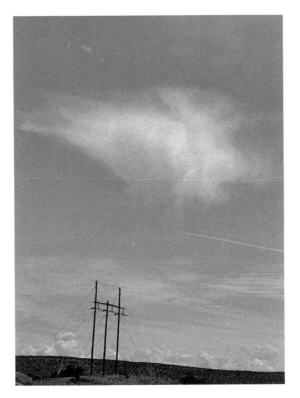

And man

makes

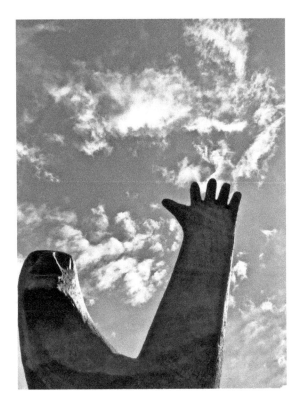

his mark.

With Gratitude

References

Page	Year	Location
4	2021	From Zocalo, Santa Fe, NM
6	2021	Zocalo, Santa Fe, NM
7	2018	Turquoise Trail, Santa Fe, NM
8	2021	From Zocalo, Santa Fe, NM
9	2021	From Zocalo, Santa Fe, NM
10	2021	From Zocalo, Santa Fe, NM
11	2021	Zocalo, Santa Fe, NM
12	2017	North Pacific Ocean
13	2017	Durango, CO
14	2021	Santa Fe, NM
15	2018	Santa Fe, NM
16	2021	Santa Fe, NM
17	2021	Santa Fe, NM
18	2018	Santa Fe, NM
19	2019	San Juan National Forrest, CO
20	2019	San Juan National Forrest, CO
21	2019	Durango, CO
22	2019	Santa Fe, NM
23	2019	Santa Fe, NM
24	2020	Santa Fe, NM
25	2020	Bloomfield, NM
26	2020	Santa Fe, NM
27	2021	Santa Fe, NM
28	2021	Santa Fe, NM
29	2021	Santa Fe, NM
30	2021	From Zocalo, Santa Fe, NM
31	2021	From Zocalo, Santa Fe, NM

References

32	2020	Santa Fe, NM
33	2021	Santa Fe, NM
34	2021	Santa, Fe, NM
35	2021	From Zocalo, Santa Fe, NM
36	2021	From Zocalo, Santa Fe, NM
37	2021	From Zocalo, Santa Fe, NM
38	2021	From Zocalo, Santa Fe, NM
39	2021	Santa Fe, NM
40	2021	From Zocalo, Santa Fe, NM
41	2020	Santa Fe, NM
42	2021	From Zocalo, Santa Fe, NM
43	2021	Santa Fe, NM
44	2021	Santa Fe, NM
45	2021	From Zocalo, Santa Fe, NM
46	2021	From Zocalo, Santa Fe, NM
47	2021	From Zocalo, Santa Fe, NM
48	2021	From Zocalo, Santa Fe, NM
49	2021	From Zocalo, Santa Fe, NM
50	2021	From Zocalo, Santa Fe, NM
51	2021	From Zocalo, Santa Fe, NM
52	2021	From Zocalo, Santa Fe, NM
53	2021	From Zocalo, Santa Fe, NM
54	2021	From Zocalo, Santa Fe, NM
55	2021	From Zocalo, Santa Fe, NM
56	2021	From Zocalo, Santa Fe, NM
57	2021	From Zocalo, Santa Fe, NM
58	2021	From Zocalo, Santa Fe, NM
59	2021	From Zocalo, Santa Fe, NM

References

60	2021	From Zocalo, Santa Fe, NM
61	2021	From Zocalo, Santa Fe, NM
62	2021	From Zocalo, Santa Fe, NM
63	2021	From Zocalo, Santa Fe, NM
64	2021	From Zocalo, Santa Fe, NM
65	2021	From Zocalo, Santa Fe, NM
66	2021	Santa Fe, NM
67	2021	Zocalo, Santa Fe, NM
68	2021	Springer, NM
69	2021	Cimarron, NM
70	2021	From Zocalo, Santa Fe, NM
71	2021	From Zocalo, Santa Fe, NM
72	2021	From Zocalo, Santa Fe, NM
73	2021	Santa Fe, NM
74	2021	Santa Fe, NM
75	2021	Santa Fe, NM
76	2021	Zocalo, Santa Fe, NM
77	2021	Santa Fe, NM
78	2021	From Zocalo, Santa Fe, NM
79	2021	Santa Fe, NM
80	2021	Santa Fe, NM
81	2021	Santa Fe, NM
82	2018	Durango, CO
83	2021	Santa Fe, NM
84	2020	Zocalo, Santa Fe, NM
85	2021	From Zocalo, Santa Fe, NM
86	2021	From Zocalo, Santa Fe, NM
87	2021	From Zocalo, Santa Fe, NM

References

88	2021	Santa Fe, NM
89	2021	Santa Fe, NM
90	2021	From Zocalo, Santa Fe, NM
91	2021	From Zocalo, Santa Fe, NM
92	2021	From Zocalo, Santa Fe, NM
93	2021	From Zocalo, Santa Fe, NM
94	2021	From Zocalo, Santa Fe, NM
95	2021	From Zocalo, Santa Fe, NM
96	2021	From Zocalo, Santa Fe, NM
97	2021	From Zocalo, Santa Fe, NM
98	2021	From Zocalo, Santa Fe, NM
99	2021	Santa Fe, NM
100	2021	Santa Fe, NM
101	2021	Santa Fe, NM
102	2021	Santa Fe, NM
103	2020	Zocalo, Santa Fe, NM
104	2021	Santa Fe, NM
105	2021	From Zocalo, Santa Fe, NM
106	2021	Santa Fe, NM
107	2021	Santa Fe, NM
108	2021	Santa Fe, NM
109	2021	Santa Fe, NM
110	2021	From Zocalo, Santa Fe, NM
111	2021	From Zocalo, Santa Fe, NM
112	2021	Santa Fe, NM
113	2021	From Zocalo, Santa Fe, NM
114	2017	San Juan National Forest, CO
115	2021	Santa Fe, NM

References

116	2021	Santa Fe, NM
117	2021	Santa Fe, NM
118	2017	Kayenta, AZ
119	2021	Santa Fe, NM
120	2021	From Zocalo, Santa Fe, NM
121	2021	From Zocalo, Santa Fe, NM
122	2019	Arnarstapi, Iceland
123	2021	Santa Fe, NM
124	2021	Santa Fe, NM
125	2021	Santa Fe, NM
126	2021	From Zocalo, Santa Fe, NM
127	2021	From Zocalo, Santa Fe, NM
128	2021	Santa Fe, NM
129	2021	From Zocalo, Santa Fe, NM
130	2021	Santa Fe, NM
131	2021	From Zocalo, Santa Fe, NM
132	2021	From Zocalo, Santa Fe, NM
133	2021	From Zocalo, Santa Fe, NM
134	2021	From Zocalo, Santa Fe, NM
135	2021	From Zocalo, Santa Fe, NM
136	2021	From Zocalo, Santa Fe, NM
137	2021	From Zocalo, Santa Fe, NM
138	2021	From Zocalo, Santa Fr, NM
139	2021	From Zocalo, Santa Fe, NM
140	2021	From Zocalo, Santa Fe, NM
141	2021	Zocalo, Santa Fe, NM
142	2021	From Zocalo, Santa Fe, NM
143	2021	Zocalo, Santa Fe, NM

References

144	2021	From Zocalo, Santa Fe, NM
145	2021	From Zocalo, Santa Fe, NM
146	2021	From Zocalo, Santa Fe, NM
147	2021	From Zocalo, Santa Fe, NM
148	2021	From Zocalo, Santa Fe, NM
149	2021	From Zocalo, Santa Fe, NM
150	2021	From Zocalo, Santa Fe, NM
151	2021	From Zocalo, Santa Fe, NM
152	2018	San Juan National Forest, CO
153	2019	San Juan National Forest, CO
154	2021	from Zocalo, Santa Fe, NM
155	2021	from Zocalo, Santa Fe, NM
156	2019	Reykjavic, Iceland
157	2021	Santa Fe, NM
158	2018	San Juan National Forest, CO
159	2018	Grand Canyon, AZ
160	2018	Grand Canyon, AZ
161	2019	Trimble Lane, Durango, CO
162	2019	Santa Fe, NM
163	2019	Santa Fe, NM
164	2019	Santa Fe, NM
165	2019	Reykjavik, Iceland
166	2020	Zocalo, Santa Fe, NM

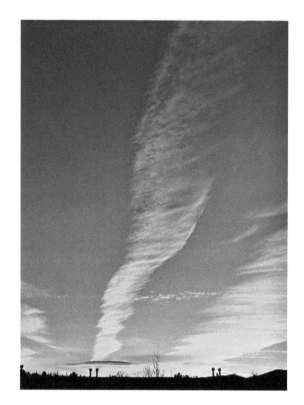

To my Neighbors from Sunrise

174

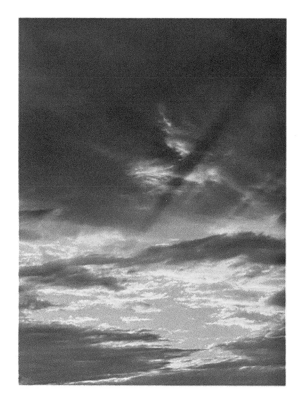

to Sunset.

CPSIA information can be obtained
at www.ICGtesting.com
Printed in the USA
BVHW021413040122
625366BV00019B/1050